One Hundred Flowers

Sam Gardiner

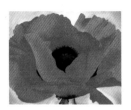

1 *Red Poppy*, 1927

A flower is relatively small. Everyone has many associations with a flower — the idea of flowers. You put out your hand to touch the flower — lean forward to smell it — maybe touch it with your lips almost without thinking — or give it to someone to please them. Still — in a way — nobody sees a flower — really — it is so small — we haven't time — and to see takes time like to have a friend takes time. If I could paint the flower exactly as I see it no one would see what I see because I would paint it small like the flower is small.

Georgia O'Keeffe, "About Myself," 1939

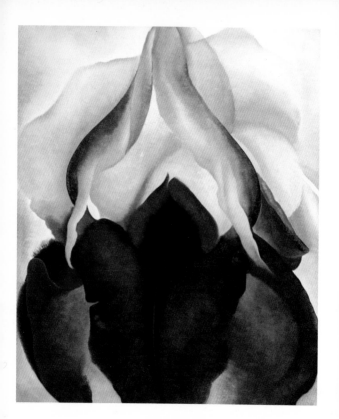

2 *Black Iris*, 1926

One Hundred Flowers

Edited by Nicholas Callaway

Phaidon · Oxford

Phaidon Press Limited, Musterlin House, Jordan Hill Road, Oxford OX2 8DP.
First published in Great Britain in 1987. Gift Edition 1990.
Copyright © 1987 by Callaway Editions, Inc., 54 Seventh Avenue South, New York, NY 10014.

A CIP catalogue record for this book is available from the British Library.

ISBN 0 7148 2696 0

The Alexander Calder ornament is reproduced courtesy of the Estate of Alexander Calder.
The statement by Georgia O'Keeffe that follows Plate 1 is excerpted from a text entitled
"About Myself," published in the catalogue accompanying her 1939 exhibition at
An American Place, New York. The Georgia O'Keeffe quotation on the back jacket is
excerpted from an interview with Mary Braggiotti, "Her Worlds Are Many,"
New York Post (16 May 1946).

Front Jacket: Jimson Weed, 1932. Oil on canvas, 48 x 40 inches (121.9 x 101.6 cm). Estate of Anita
O'Keeffe Young. (Plate 96). Back Jacket: Red Poppy, 1927. Oil on canvas,
7 ⅛ x 9 inches (18.1 x 22.9 cm). Private Collection. (Plate 1). Inside Front Jacket: Calla Lilies,
1923. Oil on canvas, 32 x 12 inches (81.3 x 30.5 cm). Private Collection. (Plate 50).
Inside Back Jacket: Iris, 1929 [Dark Iris No. 2, 1927]. Oil on canvas, 32 x 12 inches
(81.3 x 30.5 cm). Colorado Springs Fine Arts Center, Anonymous Gift. (Plate 32).
Frontispiece: Black Iris, 1926 [The Dark Iris No. III, 1926]. Oil on canvas,
36 x 29 ⅞ inches (91.4 x 75.9 cm). The Metropolitan Museum of Art.
Alfred Stieglitz Collection, 1969. Courtesy Estate of Georgia O'Keeffe. (Plate 2). Facing Page: Georgia
O'Keeffe, Lake George, 1918. Photograph by Alfred Stieglitz. Silver chloride print, 3 ⁹⁄₁₆ x 4 ⁹⁄₁₆ inches
(9 x 11.6 cm). Courtesy of Gilman Paper Company Collection. Last Page: Georgia O'Keeffe,
Abiquiu, New Mexico, c. 1951. Photograph by Doris Bry. Gelatin silver print,
6 11/16 x 4 ¾ inches (17 x 12.1 cm). Copyright © 1987 Doris Bry.

Printed and bound in Japan.

Georgia O'Keeffe, Lake George, 1918. Photograph by Alfred Stieglitz

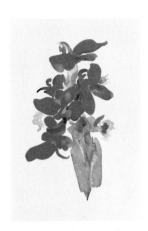

3 *Red Canna*, c. 1919

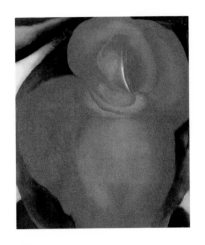

4 *Red Flower*, c. 1918–19

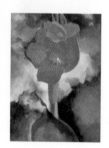

5 *Red Canna*, 1919 6 *Red Canna*, c. 1919

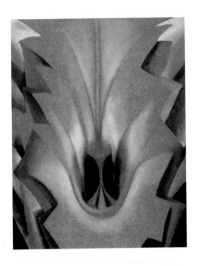

7 *Inside Red Canna*, 1919

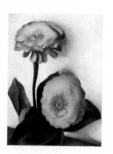

8 *Zinnias*, c. 1920

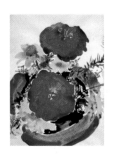

9 [*Still Life — Zinnias*], c. 1920

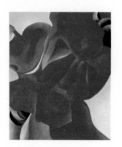

10 *Red Canna*, 1923

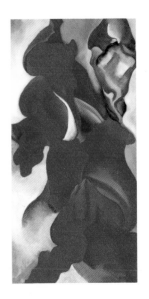

11 *Red Snapdragons*, c. 1923

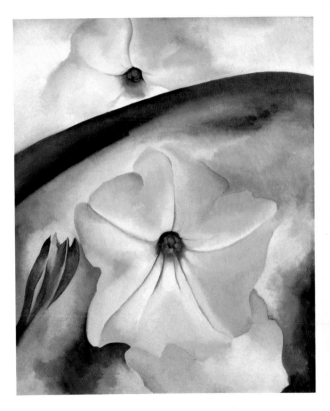

12 *Petunia No. 2*, 1924

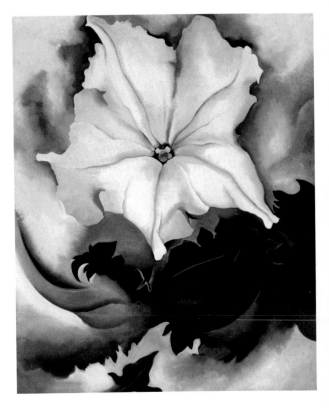

13 *Petunia and Coleus*, 1924

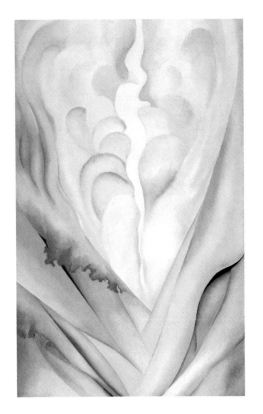

14 *Flower Abstraction*, 1924

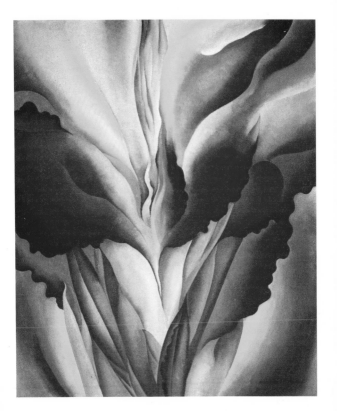

15 *Red Canna*, c. 1924

16 *Purple Petunia*, c. 1925

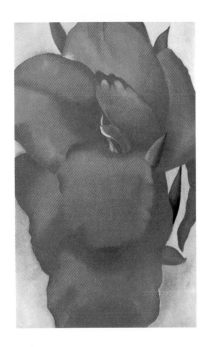

17 *Red Canna*, 1925

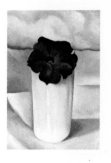

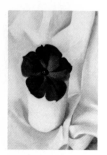

18 *Petunia, Lake George*, 1925 19 *Petunia*, 1925

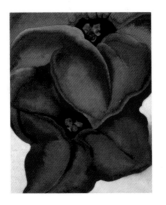

20 *Purple Petunias*, 1925

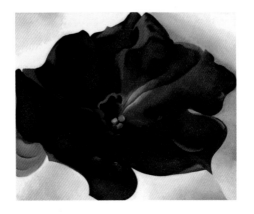

21 *Petunia*, 1925

22 *Bleeding-Heart*, c. 1928 23 *Blue Flower*, 1924–28

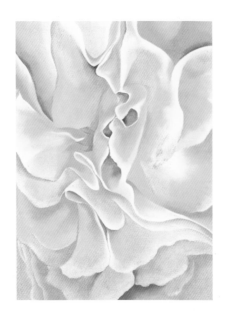

24 *Yellow Sweet Peas*, 1925

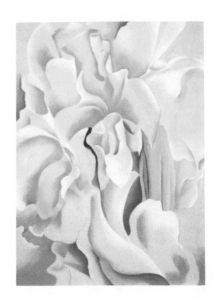

25 *White Sweet Peas*, 1926

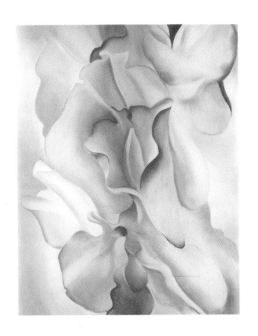

26 *Pink Sweet Peas*, 1927

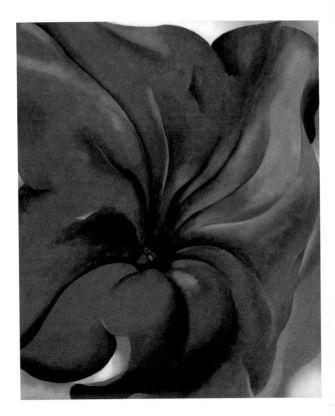

27 *Purple Petunia*, 1927

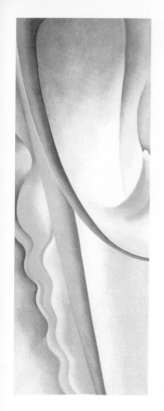

28 *Abstraction—77*, 1925

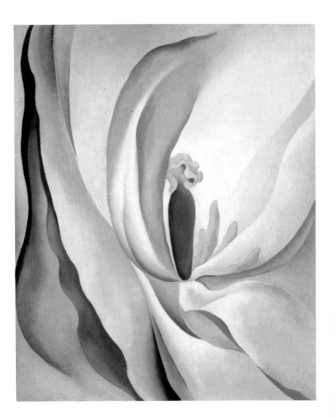

29 *Pink Tulip*, 1926

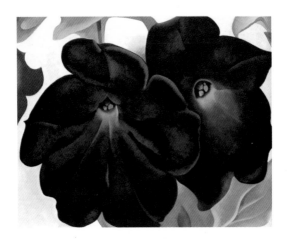

30 *Black and Purple Petunias*, 1925

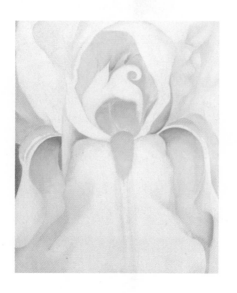

31 *White Iris*, c. 1926

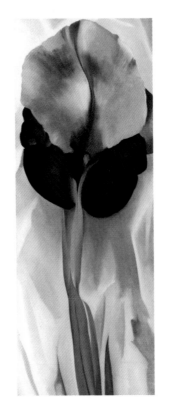

32 *Iris*, 1929

33 *The Dark Iris No. II*, 1926

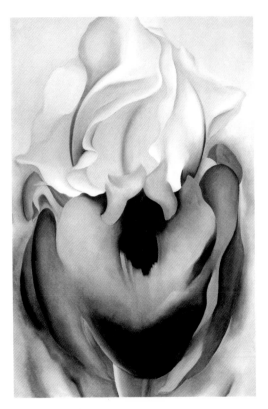

34 *Black Iris II*, 1936

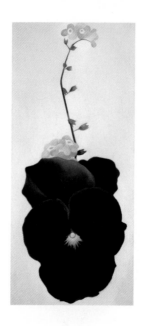

35 *Pansy*, 1926

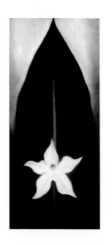

36 *Nicotina*, c. 1926

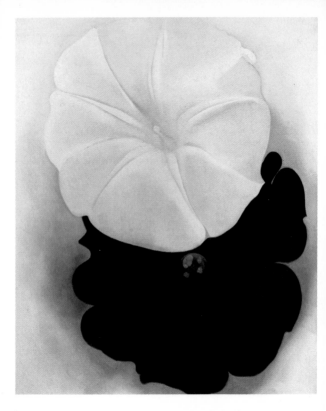

37 *Black Petunia & White Morning-Glory I*, 1926

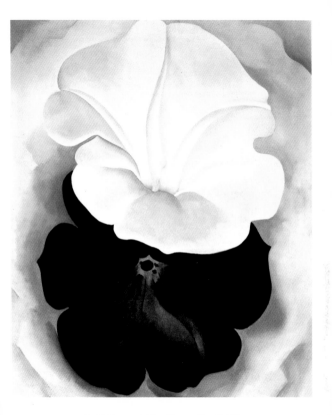

38 *Black Petunia & White Morning-Glory II*, 1926

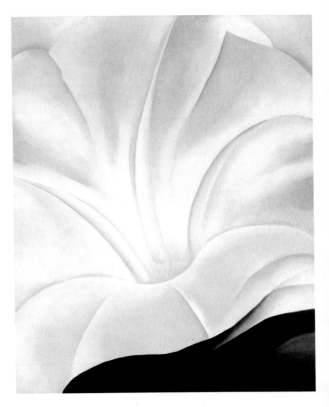

39 *Morning-Glory with Black*, 1926

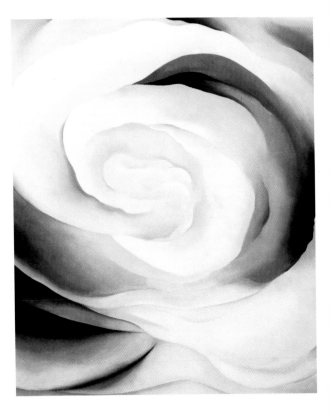

40 *Abstraction—White Rose No. 2*, 1927

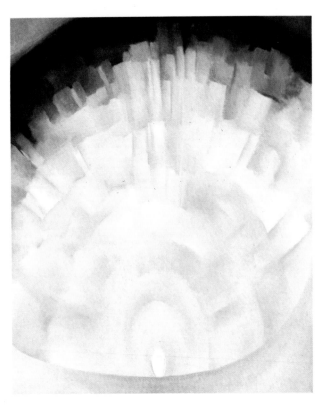

41 *Abstraction—White Rose No. 3*, 1927

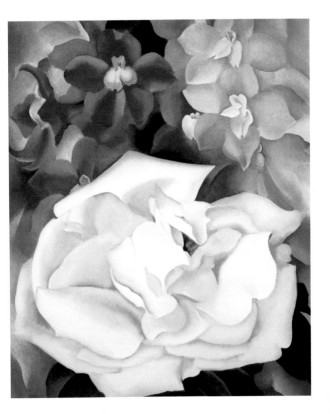

42 *White Rose with Larkspur No. 1*, 1927

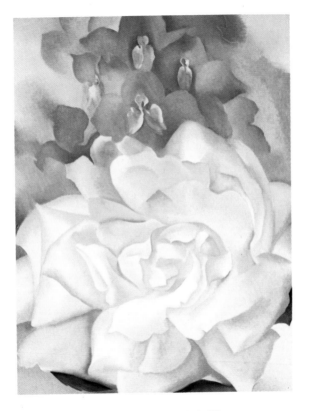

43 *White Rose with Larkspur No. 2*, 1927

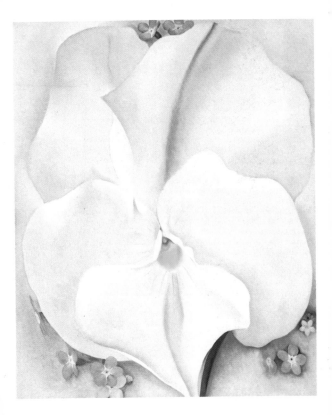

44 *White Pansy*, 1927

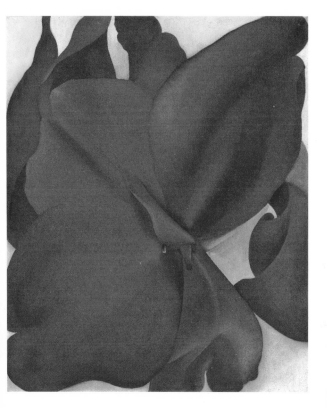

45 *Red Cannas*, 1927

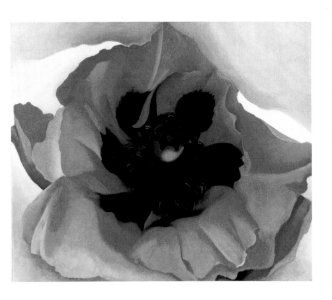

46 *Poppy*, 1927

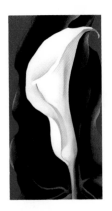

47 *Single Lily with Red*, 1928

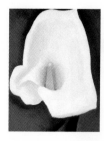

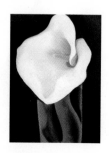

48 *Calla Lily with Red Background*, 1923 49 *Calla Lily*, 1923

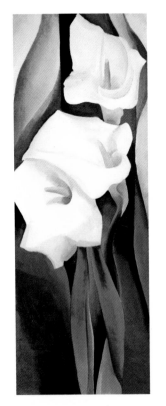

50 *Calla Lilies*, 1923

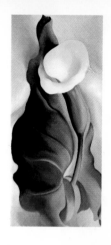

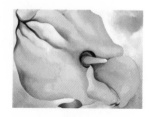

51 *Lily—Yellow No. 2*, 1927 52 *Yellow Calla*, 1926

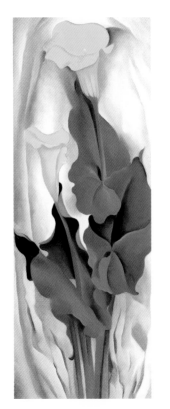

53 *Yellow Calla—Green Leaves*, 1927

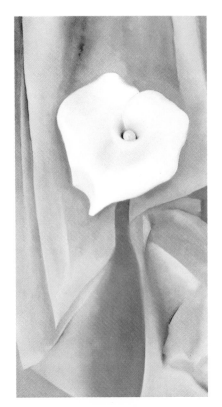

54 *Calla Lily on Grey*, 1928

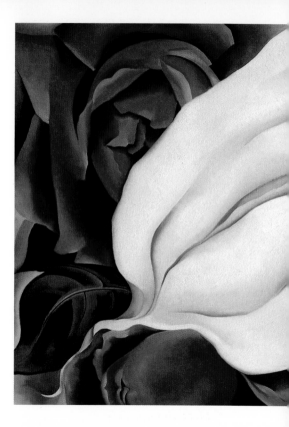

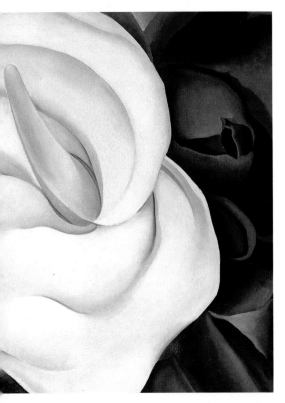

55 *Calla Lily with Red Roses*, 1926

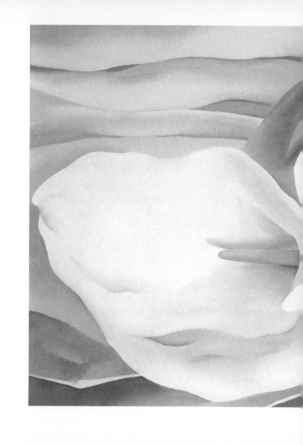

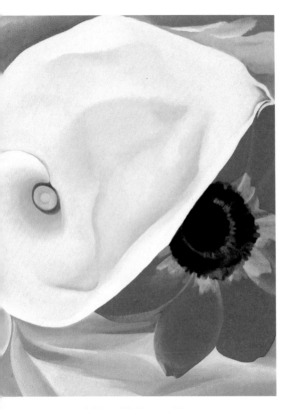

56 *Calla Lilies with Red Anemone*, 1928

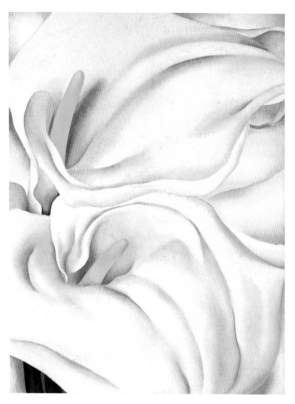

57 *Two Calla Lilies on Pink*, 1928

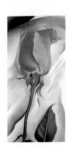

58 *Pink Rose*, 1928

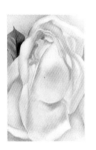

59 *White Rose*, 1928

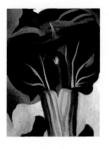

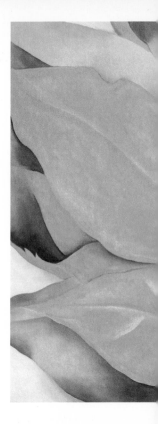

60 *Jack-in-the-Pulpit No. 1*, 1930

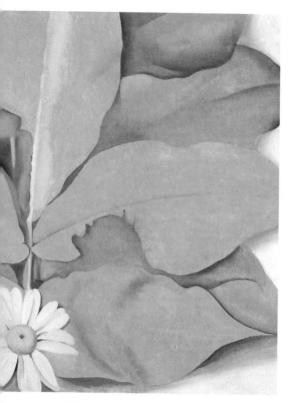

61 *Yellow Hickory Leaves with Daisy*, 1928

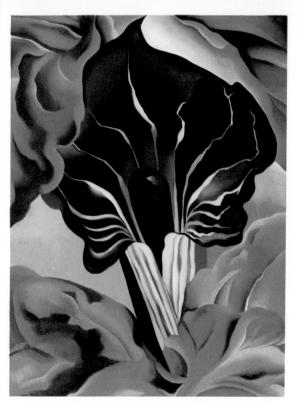

62 *Jack-in-the-Pulpit No. 2*, 1930

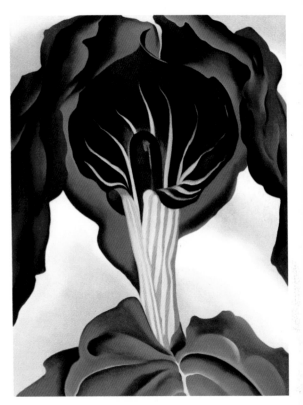

63 *Jack-in-the-Pulpit No. 3*, 1930

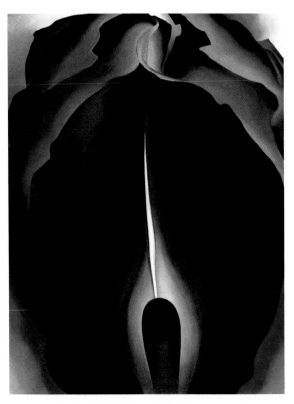

64 *Jack-in-the-Pulpit No. 4*, 1930

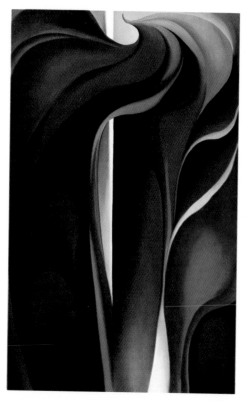

65 *Jack-in-the-Pulpit No. 5*, 1930

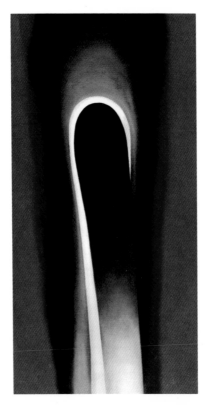

66 *Jack-in-the-Pulpit No. 6*, 1930

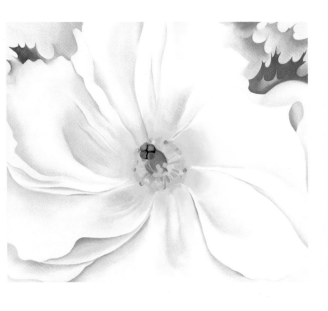

67 *White Flower*, 1929

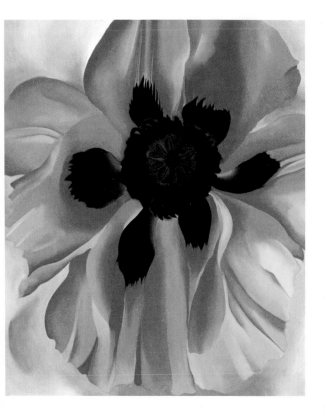

68 *Red Poppy No. VI*, 1928

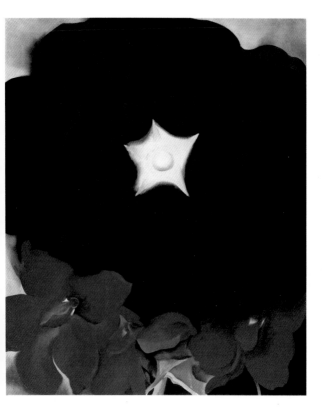

69 *Black Hollyhock, Blue Larkspur*, 1929

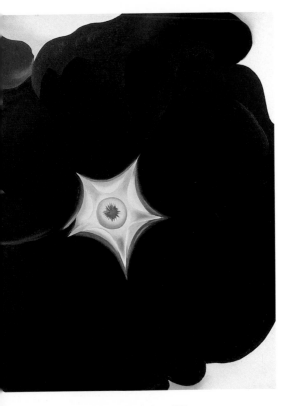

70 *Black Hollyhock, Blue Larkspur*, 1929

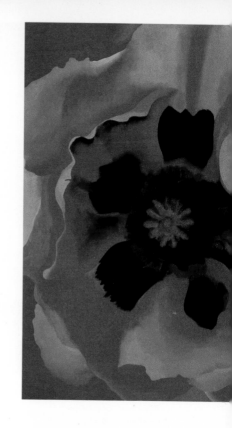

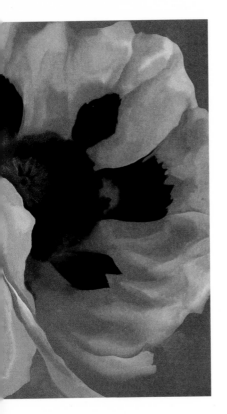

71 *Oriental Poppies*, 1928

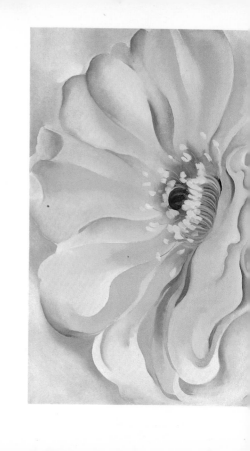

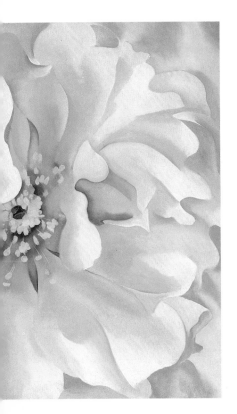

72 *Yellow Cactus Flowers*, 1929

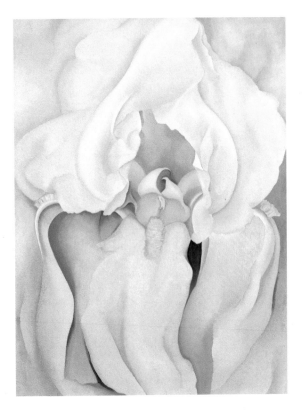

73 *Light Iris*, 1930

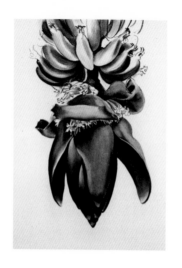

74 *Banana Flower No. 1*, 1933

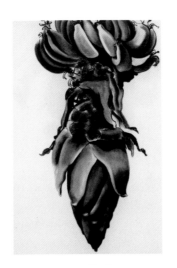

75 *Banana Plant No. 4*, 1933

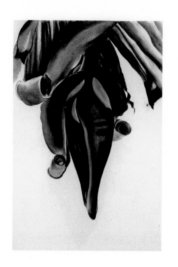

76 *Banana Flower*, 1933

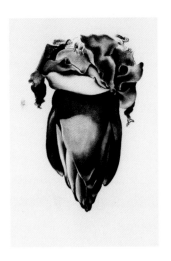

77 *Banana Flower*, 1933

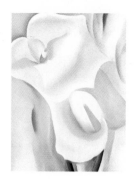

78 *Calla Lilies*, 1930

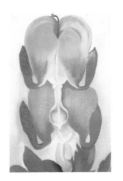

79 *Bleeding-Heart*, 1932

80 *Spotted Lily*, 1935

81 *Pink Roses and Larkspur*, 1931

82 *Lilac, Carnation, Tulip*, 1938

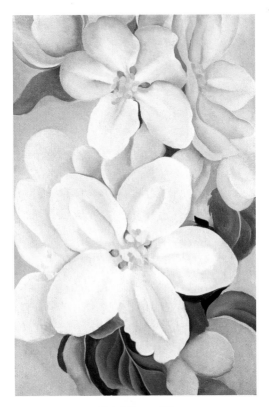

83 *Apple Blossoms*, 1930

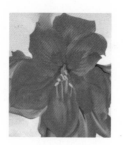

84 *Red Amaryllis*, 1937

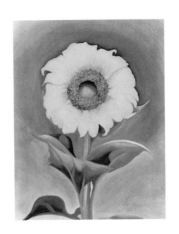

85 *Sunflower, New Mexico, II*, 1935

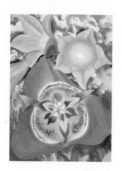

86 *Mountain Flowers, Mariposa Lily*, 1940

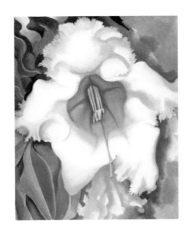

87 *Cup of Silver*, 1939

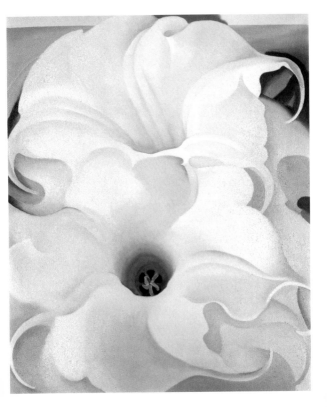

88 *Two Jimson Weeds*, 1939

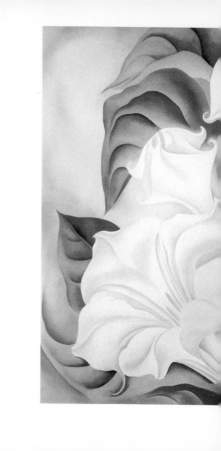

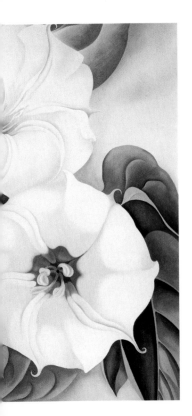

89 *The Miracle Flower*, 1936

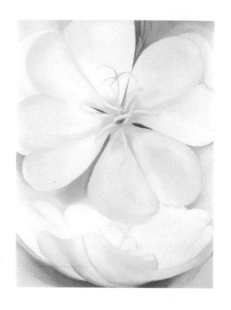

90 *White Primrose*, 1947

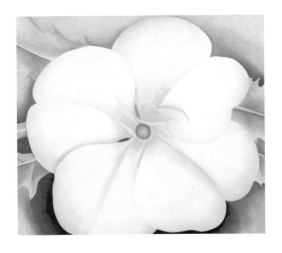

91 *White Flower on Red Earth No. 1*, 1943

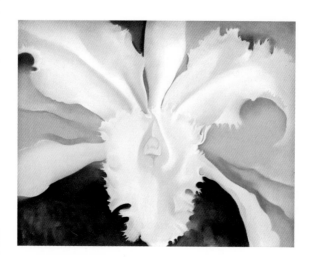

92 *Narcissa's Last Orchid*, 1941

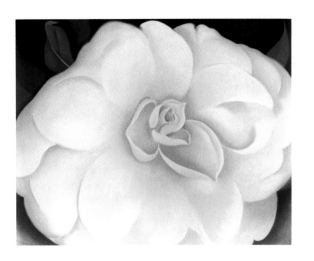

93 *White Camellia*, 1938

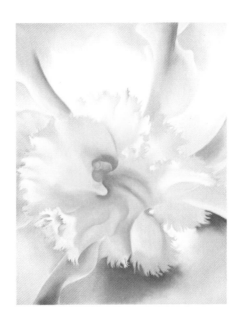

94 *An Orchid*, 1941

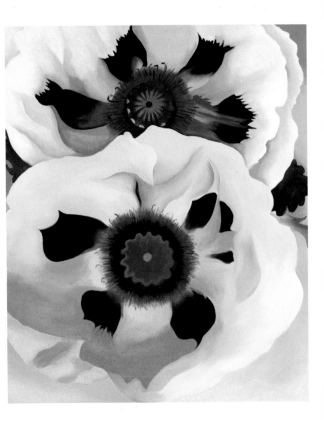

95 *Poppies*, 1950

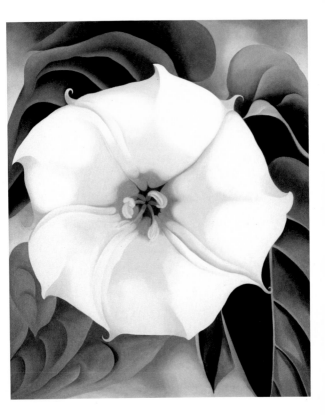

96 *Jimson Weed*, 1932

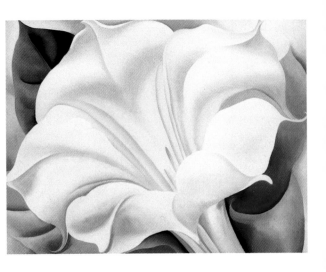

97 *The White Trumpet Flower*, 1932

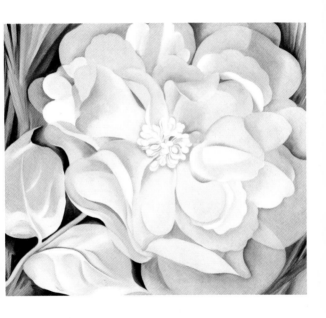

98 *The White Calico Flower*, 1931

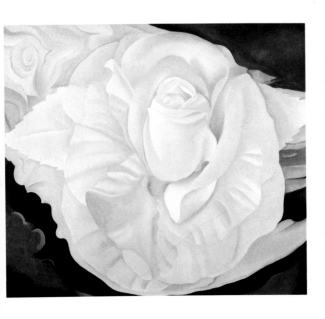

99 *White Rose, New Mexico*, 1930

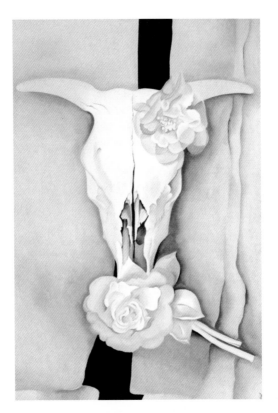

100 *Cow's Skull with Calico Roses*, 1931

Afterword

Georgia O'Keeffe was not a flower painter. She may be, however, the greatest painter of flowers in the history of Western art. She always stressed the primacy of the artist's vision over subject matter, and staunchly resisted those who would categorize her work by genre, school, or gender.

It would be incorrect to assess O'Keeffe's contribution to twentieth century American art on the basis of the flower paintings alone. In her exhibitions and books, she took care to ensure that all of her themes — abstractions, desert landscapes, city views, bones, shells, flowers, and other natural forms — be seen in relation to each other. Nevertheless, it is important to look at this body of work as a whole, because it occupied a place in O'Keeffe's life and art that is distinct and distinctive.

By the end of her ninety-eight years, she had made over two hundred flower paintings, the majority produced in a period of extraordinary and sustained creativity that lasted from 1918 to 1932. When O'Keeffe began to paint flow-

ers she was a young woman of thirty, and very much in love with Alfred Stieglitz, a world-renowned photographer. They had met in 1916 when Stieglitz first exhibited her work in New York at his gallery *291*, the center of avant-garde art in America. Here he showed in 1916 and 1917 the landmark group of purely abstract drawings and watercolors O'Keeffe had completed on her own while teaching in South Carolina and Texas. Their life together in New York began in 1918. In the summer of 1923, Stieglitz mounted an exhibition of one hundred oils, drawings, and watercolors by O'Keeffe that included her first small flower paintings. The first large-scale canvases were completed in 1924, the year of their marriage, and were shown in 1925 at the "Seven Americans" exhibition held by Stieglitz at the Anderson Galleries.

When these giant flowers were exhibited, they caused a sensation, eliciting a host of reactions ranging from critical raves to outrage to awe. One reviewer said that confronting an O'Keeffe flower painting tends to make the viewer feel "as if we humans were butterflies."[1] Even Stieglitz's first reaction to them was equivocal; when O'Keeffe called him into her studio to show him *Petunia No. 2*, 1924 (Plate 12), his first response was: "Well, Georgia, I don't know how you're going to get away with anything like that—you aren't planning to show it, are you?"[2]

A number of things about these paintings stunned viewers. The first was their physical size in relation to the actual dimensions of the subject. O'Keeffe took an object that in reality might be only an inch or so tall and enlarged it, sometimes up to 48 inches high. The largest was the 6 x 7 foot *Miracle Flower* from 1936 (Plate 89). (It is interesting, though, that even O'Keeffe's tiny 7 x 9 inch oils, like Plates 1 and 33, often have the same monumentality.) Most often the blossom was shown in extreme close-up and in minute detail. The combination of size and scale was overwhelming. In 1938, James W. Lane wrote in

Apollo magazine, "The observer feels like Alice after she had imbibed the 'Drink Me' phial." Another writer imagined these colossal flowers as a "boutonnière for Gargantua."[3]

O'Keeffe was aiming for this impact, as she explained in a 1946 interview in the *New York Post*:

"When you take a flower in your hand and really look at it," she said, cupping her hand and holding it close to her face, *"it's your world for the moment. I want to give that world to someone else. Most people in the city rush around so, they have no time to look at a flower. I want them to see it whether they want to or not."*[4]

O'Keeffe's palette was as startling as the gigantic scale of her canvases. No American painter had explored such radical combinations of color nor such astonishing intensity of hue. The colors favored at that time by her contemporaries and colleagues were for the most part "dreary," as she called them — somber and low-toned. The flower paintings are as much about pure color — sometimes riotous, sometimes almost purely monochromatic — as they are about subject matter. In the 1930s, O'Keeffe wrote about the *White Flower*, 1929 (Plate 67):

Whether the flower or the color is the focus I do not know. I do know that the flower is painted large to convey to you my experience of the flower — and what is my experience of the flower — if it is not color.[5]

Her friend, the painter Charles Demuth, described O'Keeffe's color sense in the brochure accompanying her 1927 exhibit at The Intimate Gallery:

Flowers and flames. And colour. Colour as colour, not as volume, or light, —

only as colour. The last mad throb of red just as it turns green, the ultimate shriek of orange calling upon all the blues of heaven for relief or for support, these Georgia O'Keeffe is able to use. In her canvases each colour almost regains the fun it must have felt within itself, on forming the first rain-bow.

A great hubbub arose among the public and the critics about the connotations of the flower paintings. Many found them to be unabashedly sensual, in some cases overtly erotic. Others perceived them as spiritually chaste. There are stories of parents who used O'Keeffe's flowers to teach their children about the birds and the bees; and there are tales of clergy who revered her calla lilies as portrayals in paint of the Immaculate Conception, leading Stieglitz to proclaim O'Keeffe's art as "the beginning of a new religion."[6] But on the subject of sex and religion in these works, one must draw one's own conclusions.

Added to the shock of their spectacular size, outrageous color, and scandalous (or sacred) shapes was the fact that these paintings had been created by a woman at a time when the art world was almost exclusively male. O'Keeffe had already attracted attention in the two earlier exhibits of her work at 291, and in Stieglitz's composite photographic portrait of her, including many nudes, first shown in 1921. The flower paintings further fueled the public's fascination with this woman who so freely exposed herself, and yet retained so much mystery. They were extraordinarily controversial and sought-after, and made their maker a celebrity. It was the flowers that begat the O'Keeffe legend in the heady climate of the 1920s.

O'Keeffe had the great daring to lay herself bare, literally and figuratively, at this time in her art and in her life. Stieglitz was right when he said, "O'Keeffe let herself be seen, gave herself like a flower and for an American woman that was too remarkable."[7] And it proved too much for her; the extraordinary self-

revelation of these years was contrasted later on by an equally fierce demand for privacy and solitude.

In the summer of 1929, O'Keeffe made a trip to New Mexico, and though she completed several great paintings of flowers there, it was the desert landscape that entranced her. Her first paintings of bones, which symbolized the desert for her, date from 1930, and were combined with flowers. She shipped back East a big wooden barrel full of bones and animal skulls, their crevices stuffed with the calico flowers which Hispanic people of the Southwest used to ornament graves. In the summer of 1931, back at Lake George, she recalled in later years, "I was looking through them one day when someone came to the kitchen door. As I went to answer the door, I stuck a pink rose in the eye socket of a horse's skull. And when I came back the rose in the eye looked pretty fine, so I thought I would just go on with that."8 That same year, she did go on to *Cow's Skull with Calico Roses*, 1931 (Plate 100), which incorporated the fabric flowers from her extraordinary works *The White Calico Flower*, 1931 (Plate 98) and *White Rose, New Mexico*, 1930 (Plate 99). These paintings marked a turning point in O'Keeffe's life. After this time, she spent much of the year in New Mexico, apart from Stieglitz, and the desert replaced flowers as her primary motif.

It must have been a great relief for her to paint in the desert, in respite from the storm of attention that always seemed to surround her in New York. She could focus on a subject that was close to her heart, yet one that was freed from all of the readings that people had brought to her flowers. "A red hill doesn't touch everyone's heart as it touches mine . . . You have no associations with those hills—our waste land—I think our most beautiful country—You may not have seen it, so you want me always to paint flowers."9 The New Mexico landscape was to remain an inexhaustible source of inspiration and refuge

to her for the rest of her life. She loved the desert precisely because "it is vast and empty and untouchable—and knows no kindness with all its beauty."[10]

I am neither an art historian nor a writer, but I have been an admirer of Georgia O'Keeffe's work for fifteen years. O'Keeffe's flower paintings are so little-known today partly because they were so popular sixty years ago. They consistently sold better than her paintings of other subjects and thus became her signature work. Some entered museum collections, and some were retained by the artist, but most were purchased by private collectors, who kept them or passed them along to family or friends. Over the past half century they have become so widely scattered, and in some cases so well hidden, that the mission of finding them often made me feel more like an archaeologist and private eye than a publisher. For me and my colleagues, the task of assembling them took on the fascination of a hunt for lost treasure. Finding flowers became a delightful obsession.

This book is not definitive, but we hope that it offers a representative selection of this particular aspect of O'Keeffe's vast and monumental achievement. We spent many thousands of hours combing libraries, museums, and archives, tracing the Byzantine lineage of these works across several generations. Usually we began with a reference to a painting found in a letter, exhibition list, article, or catalogue. Sometimes we had no more to work with than a title (often shared by ten other paintings), date (often incorrectly listed), and perhaps the name of a collector who purchased it in 1924, with no address or other information of any kind. We offer our thanks to the myriad collectors, museum curators, gallery owners, family genealogists, and doormen we ruthlessly pestered for clues.

In the course of our research, I've heard many "flower stories" and met many extraordinary people. One of my favorite images is of the collector in her mid-nineties who has treasured a small, jewel-like O'Keeffe flower since she purchased it in the 1920s from Alfred Stieglitz. I am told that she wakes late each morning and walks straight past her Picassos and Matisses to sit for much of the day admiring her O'Keeffe.

One woman told me that her O'Keeffe painting of a petunia was a gift to her from her mother on the day she was born, so that "she would begin life in the right way."

Another work was sold in the 1930s by Alfred Stieglitz to a young woman who very much admired O'Keeffe. He showed her a selection of paintings, and she chose a tiny rosebud. Stieglitz then disappeared into the back room at An American Place and returned with one of his abstract cloud photographs, known as *Equivalents*. He gave it to her on the condition that the two works would always remain side by side. And they have.

A few months ago, as our project neared completion, I realized that I began this book unwittingly the day I first met Georgia O'Keeffe. It was in June 1973, and I was a student in fine arts at Harvard College. I was interested in the work of Stieglitz, and, through his portraits of O'Keeffe, became enamored of her paintings and her personality. The day before graduation one of my art professors told me it was rumored that O'Keeffe would receive an honorary degree from the University the next day. I was awestruck; it had never occurred to me that I might one day have the chance to see in person the extraordinary face and profile that had been immortalized by Stieglitz.

The next morning, I went to the florist in Harvard Square and bought my

favorite flower, a giant white peony. I ran into the yard as the ceremony began, and joined the crowds lining the path of the procession. When O'Keeffe filed past, I stepped out and handed her the flower, saying, "This is for you, Miss O'Keeffe." Without missing a step, and without turning her head to the side, she firmly grasped the flower in her hand, and continued on without speaking.

When I gave Miss O'Keeffe that peony on a late spring day nearly fifteen years ago I had no inkling of how grand and glorious was the bouquet that she would render. As I see these blossoms arrayed before me, I know that no one ever has nor ever will paint flowers the way that Georgia O'Keeffe did, for one simple reason. To paraphrase what she published about Stieglitz in 1978, O'Keeffe's eye was in her, and that way she was always painting herself.[11]

These works of art are the self-portrait of a woman and of an artist in full bloom. They are extraordinary *because* of the complexity and richness of their intimations. They speak of many things — "the idea of filling a space in a beautiful way,"[12] the sheer joy of painting well, one woman's life. To me they are above all the most sublime expression of love that has ever been put into paint.

Nicholas Callaway
Kyoto, Japan
April 1987

1. Laurie Lisle, *Portrait of an Artist: A Biography of Georgia O'Keeffe* (New York: Seaview Books, 1980), 137.

2. Ibid.

3. Ibid.

4. Mary Braggiotti, "Her Worlds Are Many," *New York Post*, May 16, 1946.

5. William M. Milliken, "White Flower by Georgia O'Keeffe," *Bulletin of the Cleveland Museum of Art*, April 1937.

6. Herbert J. Seligmann, *Alfred Stieglitz Talking* (New Haven: Yale University Library, 1966), 41.

7. Seligmann, 71.

8. Calvin Tomkins, "The Rose in the Eye Looked Pretty Fine," *New Yorker*, March 4, 1974, 50.

9. Excerpted from the text entitled "About Myself," published in the catalogue accompanying O'Keeffe's 1939 exhibition at An American Place, New York.

10. Ibid.

11. From her preface to *Georgia O'Keeffe: A Portrait by Alfred Stieglitz* (New York: The Metropolitan Museum of Art/The Viking Press, 1978).

12. Georgia O'Keeffe, *Georgia O'Keeffe* (New York: The Viking Press, 1976), opposite Plate 11.

List of Plates

8 *Zinnias*, c. 1920
 Oil on canvas
 12 x 9 inches (30.5 x 22.9 cm)
 Courtesy Richard T. York, New York

9 [*Still Life — Zinnias*], c. 1920
 Watercolor on paper
 11 1/2 x 8 1/4 inches
 (29.2 x 21 cm)
 Private Collection

10 *Red Canna*, 1923
 Oil on canvas
 12 x 9 7/8 inches (30.5 x 25.1 cm)
 Collection of Mr. and Mrs.
 Meyer P. Potamkin

11 *Red Snapdragons*, c. 1923
 Oil on canvas
 20 1/4 x 10 1/4 inches (51.4 x 26 cm)
 Private Collection

12 *Petunia No. 2*, 1924
 Oil on canvas
 36 x 30 inches (91.4 x 76.2 cm)
 Estate of Anita O'Keeffe Young

13 *Petunia and Coleus*, 1924
 Oil on canvas
 36 x 30 inches (91.4 x 76.2 cm)
 Private Collection
 Courtesy Washburn Gallery
 New York

14 *Flower Abstraction*, 1924
 Oil on canvas
 48 x 30 inches (121.9 x 76.2 cm)
 Whitney Museum of American Art
 Gift of Sandra Payson
 Courtesy Estate of Georgia O'Keeffe

15 *Red Canna*, c. 1924
 Oil on canvas mounted on masonite
 36 x 29 7/8 inches (91.4 x 75.9 cm)
 University of Arizona Museum of Art
 Gift of Oliver James

16 *Purple Petunia*, c. 1925
 Oil on canvas
 7 3/16 x 7 1/8 inches (18.3 x 18.1 cm)
 Private Collection

17 *Red Canna*, 1925
 Oil on canvas
 29 x 18 inches (73.7 x 45.7 cm)
 Private Collection

18 *Petunia, Lake George*, 1925
 Oil on board
 9 7/8 x 6 3/4 inches (25.1 x 17.1 cm)
 Private Collection

19 *Petunia*, 1925
 Oil on board
 10 x 7 inches (25.4 x 17.8 cm)
 Private Collection

20 *Purple Petunias*, 1925
 Oil on canvas
 15 7/8 x 13 inches (40.3 x 33 cm)
 The Newark Museum

21 *Petunia*, 1925
 Oil on canvas
 17 3/4 x 21 3/4 inches (45.1 x 55.2 cm)
 Courtesy Kennedy Galleries,
 New York

22 *Bleeding-Heart*, c. 1928
 Oil on board
 13 1/2 x 11 1/2 inches (34.3 x 29.2 cm)
 Private Collection

23 *Blue Flower*, 1924–28
Oil on board
12 3/4 x 9 1/2 inches (32.4 x 24.1 cm)
Private Collection
Courtesy Mickelson Gallery,
Washington, D.C.

24 *Yellow Sweet Peas*, 1925
Pastel on paper
26 1/2 x 19 1/4 inches (67.3 x 48.9 cm)
Courtesy Kennedy Galleries,
New York

25 *White Sweet Peas*, 1926
Pastel on paper
25 x 18 3/4 inches (63.5 x 47.6 cm)
Collection of Loretta and
Robert K. Lifton

26 *Pink Sweet Peas*, 1927
Pastel on paper
27 1/2 x 21 3/4 inches
(69.8 x 55.2 cm)
Private Collection

27 *Purple Petunia*, 1927
Oil on canvas
36 x 30 inches (91.4 x 76.2 cm)
Collection of Mr. and Mrs.
Graham Gund

28 *Abstraction — 77*, 1925
[*Pink Tulip*, 1925]
Oil on canvas
32 x 12 inches (81.3 x 30.5 cm)
Collection of Emily Fisher
Landau, New York
Courtesy Estate of Georgia O'Keeffe

29 *Pink Tulip*, 1926
Oil on canvas
36 x 30 inches (91.4 x 76.2 cm)
The Baltimore Museum of Art
Bequest of Mabel Garrison
Siemonn In Memory of her Husband,
George Siemonn

30 *Black and Purple Petunias*, 1925
Oil on board
20 x 25 inches (50.8 x 63.5 cm)
Private Collection. Courtesy Doris Bry
Courtesy Estate of Georgia O'Keeffe

31 *White Iris*, c. 1926
Oil on canvas
24 x 20 inches (61 x 50.8 cm)
Collection of Emily Fisher Landau,
New York
Courtesy Estate of Georgia O'Keeffe

32 *Iris*, 1929 [*Dark Iris No. 2*, 1927]
Oil on canvas
32 x 12 inches (81.3 x 30.5 cm)
Colorado Springs Fine Arts Center
Anonymous Gift

33 *The Dark Iris No. II*, 1926
Oil on canvas
9 x 7 inches (22.9 x 17.8 cm)
Private Collection
Courtesy Washburn Gallery,
New York

34 *Black Iris II*, 1936
[*Black Iris VI*, 1936]
Oil on canvas
36 x 24 inches (91.4 x 61 cm)
Private Collection

47 *Single Lily with Red*, 1928
[*Calla Lily on Red*, 1928]
Oil on wood
12 x 6 1/4 inches (30.5 x 15.9 cm)
Whitney Museum of American Art

48 *Calla Lily with
Red Background*, 1923
Oil on board
8 9/16 x 6 9/16 inches (21.7 x 16.7 cm)
Private Collection

49 *Calla Lily*, 1923
Oil on board
12 x 9 inches (30.5 x 22.9 cm)
Private Collection

50 *Calla Lilies*, 1923
Oil on board
32 x 12 inches (81.3 x 30.5 cm)
Private Collection

51 *Lily — Yellow No. 2*, 1927
Oil on canvas
20 x 9 inches (50.8 x 22.9 cm)
The Gerald Peters Gallery, Santa Fe

52 *Yellow Calla*, 1926
Oil on fiberboard
9 3/8 x 12 3/4 inches (23.8 x 32.4 cm)
National Museum of American Art
Smithsonian Institution
Gift of the Woodward Foundation

53 *Yellow Calla — Green Leaves*, 1927
[*Lily — Yellow No. 1*, 1927]
Oil on canvas
42 x 16 inches (106.7 x 40.6 cm)
Collection of Mr. Steve Martin

54 *Calla Lily on Grey*, 1928
Oil on canvas
32 x 17 inches (81.3 x 43.2 cm)
The William H. Lane Foundation

55 *Calla Lily with Red Roses*, 1926
[*L.K. — White Calla & Roses*, 1926]
Oil on canvas
30 x 48 inches (76.2 x 121.9 cm)
Private Collection

56 *Calla Lilies with Red Anemone*,
1928
Oil on wood
30 x 48 inches (76.2 x 121.9 cm)
Private Collection

57 *Two Calla Lilies on Pink*, 1928
Oil on canvas
40 x 30 inches (101.6 x 76.2 cm)
Copyright © 1987 Estate of
Georgia O'Keeffe

58 *Pink Rose*, 1928
Oil on canvas
12 x 5 3/4 inches
(30.5 x 14.6 cm)
Private Collection

59 *White Rose*, 1928
[*A Rose on Blue*, 1928]
Oil on canvas
11 x 7 inches (27.9 x 17.8 cm)
Private Collection

60 *Jack-in-the-Pulpit No. 1*, 1930
Oil on canvas
12 x 9 inches (30.5 x 22.9 cm)
Private Collection
Courtesy ACA Galleries, New York

61 *Yellow Hickory Leaves*
 with Daisy, 1928
 Oil on canvas
 29 7/8 x 39 7/8 inches (76 x 101.3 cm)
 Gift of Georgia O'Keeffe to the
 Alfred Stieglitz Collection
 Copyright © 1987
 The Art Institute of Chicago
 All Rights Reserved

62 *Jack-in-the-Pulpit No. 2*, 1930
 Oil on canvas
 40 x 30 inches (101.6 x 76.2 cm)
 Copyright © 1987 Estate of
 Georgia O'Keeffe

63 *Jack-in-the-Pulpit No. 3*, 1930
 Oil on canvas
 40 x 30 inches (101.6 x 76.2 cm)
 Copyright © 1987 Estate of
 Georgia O'Keeffe

64 *Jack-in-the-Pulpit No. 4*, 1930
 Oil on canvas
 40 x 30 inches (101.6 x 76.2 cm)
 Copyright © 1987 Estate of
 Georgia O'Keeffe

65 *Jack-in-the-Pulpit No. 5*, 1930
 Oil on canvas
 48 x 30 inches (121.9 x 76.2 cm)
 Copyright © 1987 Estate of
 Georgia O'Keeffe

66 *Jack-in-the-Pulpit No. 6*, 1930
 Oil on canvas
 36 x 18 inches (91.4 x 45.7 cm)
 Copyright © 1987 Estate of
 Georgia O'Keeffe

67 *White Flower*, 1929
 Oil on canvas
 30 1/8 x 36 1/8 inches (76.5 x 91.8 cm)
 The Cleveland Museum of Art
 Purchased for the
 Hinman B. Hurlbut Collection

68 *Red Poppy No. VI*, 1928
 Oil on canvas
 36 x 30 inches (91.4 x 76.2 cm)
 Collection of Reed College

69 *Black Hollyhock,*
 Blue Larkspur, 1929
 Oil on canvas
 36 x 30 inches (91.4 x 76.2 cm)
 The Metropolitan Museum of Art
 George A. Hearn Fund, 1934
 Courtesy Estate of Georgia O'Keeffe

70 *Black Hollyhock,*
 Blue Larkspur, 1929
 Oil on canvas
 30 x 40 inches (76.2 x 101.6 cm)
 Estate of Anita O'Keeffe Young

71 *Oriental Poppies*, 1928
 [*Red Poppies*, 1928]
 Oil on canvas
 30 x 40 1/8 inches (76.2 x 101.9 cm)
 University Art Museum, University
 of Minnesota, Minneapolis
 General Budget Fund Purchase

72 *Yellow Cactus Flowers*, 1929
 Oil on canvas
 30 3/16 x 42 inches (76.7 x 106.7 cm)
 The Fort Worth Art Museum
 Gift of the William E. Scott
 Foundation

73 *Light Iris*, 1930
[*White Iris*, 1930]
Oil on canvas
40 x 30 inches (101.6 x 76.2 cm)
Virginia Museum of Fine Arts
Gift of Mr. and Mrs. Bruce Gottwald

74 *Banana Flower No. 1*, 1933
Charcoal on paper
22 x 15 inches (55.9 x 38.1 cm)
The Arkansas Art Center Foundation
Collection
The Museum Purchase Plan of the
N.E.A. and the Tabriz Fund, 1974

75 *Banana Plant No. 4*, 1933
Charcoal on paper
21 1/2 x 14 3/8 inches
(54.6 x 36.5 cm)
Private Collection

76 *Banana Flower*, 1933
Charcoal on paper
21 3/4 x 14 3/4 inches (55.2 x 37.5 cm)
Gift to American Association of
University Women from
Mary Alice Parrish, Ph.D., Vandalia,
Missouri

77 *Banana Flower*, 1933
Charcoal on paper
21 3/4 x 14 3/4 inches
(55.2 x 37.5 cm)
Collection, The Museum of
Modern Art, New York
Given Anonymously (by exchange)

78 *Calla Lilies*, 1930
Oil on canvas
15 x 12 1/2 inches (38.1 x 31.7 cm)
The Davis Family Fund, on loan to
the New Orleans Museum of Art

79 *Bleeding-Heart*, 1932
Pastel on paper
15 x 10 inches (38.1 x 25.4 cm)
Estate of Anita O'Keeffe Young

80 *Spotted Lily*, 1935
Watercolor and pencil on paper
15 1/4 x 12 1/2 inches (38.7 x 31.7 cm)
Courtesy Hirschl & Adler Galleries,
New York/The Gerald Peters Gallery,
Santa Fe

81 *Pink Roses and Larkspur*, 1931
Pastel on paper
16 x 12 inches (40.6 x 30.5 cm)
Private Collection
Courtesy Doris Bry, New York

82 *Lilac, Carnation, Tulip*, 1938
[*Flowers*, 1941]
Oil on board
13 3/8 x 8 1/2 inches
(34 x 21.6 cm)
Collection of Olga Hirshhorn,
Washington, D.C.

83 *Apple Blossoms*, 1930
Oil on canvas
37 x 26 inches (94 x 66 cm)
The Nelson-Atkins Museum of Art
Kansas City, Missouri
Gift of Mrs. Louis Sosland

84 *Red Amaryllis*, 1937
Oil on canvas
11 7/8 x 10 inches (30.2 x 25.4 cm)
Terra Museum of American Art,
Chicago, Illinois
Gift of Mrs. Henrietta Roig,
Winnetka, Illinois

85 *Sunflower, New Mexico, II*, 1935
Oil on canvas
19 x 13 inches (48.3 x 33 cm)
Collection of Kay and Warner LeRoy

86 *Mountain Flowers,
Mariposa Lily*, 1940
Oil on canvas
14 x 10 inches (35.6 x 25.4 cm)
Private Collection
Courtesy Richard York Gallery,
New York

87 *Cup of Silver*, 1939
Oil on canvas
19 3/16 x 16 1/8 inches
(48.7 x 41 cm)
The Baltimore Museum of Art
Gift of Cary Ross

88 *Two Jimson Weeds*, 1939
Oil on canvas
36 x 30 inches (91.4 x 76.2 cm)
Estate of Anita O'Keeffe Young

89 *The Miracle Flower*, 1936
Oil on linen
72 x 84 inches (182.9 x 213.4 cm)
Collection of Elizabeth Arden, Inc.

90 *White Primrose*, 1947
Oil on canvas
26 x 20 inches (66 x 50.8 cm)
Private Collection

91 *White Flower on
Red Earth No. 1*, 1943
Oil on canvas
26 x 30 1/4 inches (66 x 76.8 cm)
The Newark Museum

92 *Narcissa's Last Orchid*, 1941
Pastel on paper
21 1/2 x 27 1/4 inches (54.5 x 69.1 cm)
The Art Museum,
Princeton University
Gift of David H. McAlpin

93 *White Camellia*, 1938
Pastel on paper
20 5/8 x 27 3/8 inches
(52.4 x 69.5 cm)
Private Collection

94 *An Orchid*, 1941
Pastel on paper
27 x 21 inches (68.6 x 53.3 cm)
Copyright © 1987 Estate of
Georgia O'Keeffe

95 *Poppies*, 1950
Oil on canvas
36 x 30 inches (91.4 x 76.2 cm)
Milwaukee Art Museum
Gift of Mrs. Harry Lynde Bradley

96 *Jimson Weed*, 1932
Oil on canvas
48 x 40 inches (121.9 x 101.6 cm)
Estate of Anita O'Keeffe Young

97 *The White Trumpet Flower*, 1932
 Oil on canvas
 30 x 40 inches (76.2 x 101.6 cm)
 San Diego Museum of Art
 Donor Mrs. Inez Grant Parker
 In Memory of Earle W. Grant

98 *The White Calico Flower*, 1931
 Oil on canvas
 30 x 36 inches (76.2 x 91.4 cm)
 Whitney Museum of American Art

99 *White Rose, New Mexico*, 1930
 Oil on canvas
 30 x 36 inches (76.2 x 91.4 cm)
 Private Collection

100 *Cow's Skull with*
 Calico Roses, 1931
 Oil on canvas
 35 7/8 x 24 inches (91.2 x 61 cm)
 Gift of Georgia O'Keeffe
 Copyright © 1987
 The Art Institute of Chicago
 All Rights Reserved

List of Plates compiled by
Alexandra Arrowsmith.

Steven Sloman was especially commissioned to
make the 8 x 10 inch color transparencies for
this book. All color photography was by Mr.
Sloman, except for the following plates: Kerry
Dundas, 72; Gregory Heins, courtesy Art
Resource, New York, 27; L. Lorenz, 45; Alan
Newman, 84, 95; Robert Reck, 15; Trevor·
Roehl, 74; Joseph Szaszfai, 3; Malcolm Varon,
2, 28, 31, 69 all Copyright © Malcolm Varon;
Art Institute of Chicago, 61, 100; Museum of
Fine Arts, Boston, 43, 54; courtesy Gulf States
Paper Corporation, 4; courtesy James Maroney,
53; Museum of Modern Art, New York, 77;
Gerald Peters Gallery, 51.

In many instances more than one title and date
exist for a painting. When alternate titles have
been found in our research this has been noted
in square brackets. If there is a discrepancy in
the date of a work, we have so indicated in the
catalogue entry by placing a "c." (circa) before
the date that has been determined to be the
most likely.

A number of these works have been exhibited
and published both horizontally and vertically.
O'Keeffe and Stieglitz stated that certain
paintings could be viewed in different
directions, and at times they even indicated
this on the back of the canvas.

In all cases the paintings are reproduced in
their entirety.

Acknowledgments

My great thanks to the many museums, private collectors, galleries, and many more, without whose generous assistance this publication would not have been possible. I am most grateful to several individuals who have shaped this book: Kate Giel, Associate Publisher; Alexandra Arrowsmith, Editor; Steven Sloman, Photographer; Doris Bry, authority on the life and work of Georgia O'Keeffe; Hiroyuki Nakao, Hiroshi Kurosawa, and all of the extraordinary craftsmen of Nissha Printing Company. Your combined talents and your tireless pursuit of perfection are eloquently displayed on these pages.

A heartfelt thanks to Susan Ralston, Jeff Stone, and Beth Chang who supervised the first edition and softcover edition of *One Hundred Flowers*.

I would like to dedicate the gift edition to Jane Friedman, Senior Vice President at Alfred A. Knopf, who with the assistance of Anne McCormick and Anne-Lise Spitzer moved heaven and earth to make this publication possible.

N.C.

Colophon

This book has been researched, edited, designed, and produced by Callaway Editions under the direction of Nicholas Callaway; Kate Giel, Associate Publisher; and Alexandra Arrowsmith, Editor.

Art direction for the gift edition was by Caissa Douwes. Production direction was by True Sims. Additional Callaway members contributing to the gift edition were Gary Chassman, Natacha Vassilchikov, Todd Merrill, John McCormick, Ivan Wong, Jin Park, and Herz Koning.

Typographic design and layout for this edition were done by Red Square, New York, on an Apple Macintosh IIcx computer, using Microsoft Word and Aldus PageMaker. The type was set in Linotype Walbaum by Kennedy Typographers, New York. Proofreading was by Barbara Bergeron.

The ornament on the front cover is from a brooch made in 1930 by Alexander Calder for Georgia O'Keeffe. The signature is in O'Keeffe's hand. The rendering of both is by Julian Waters.

This book has been printed in four-color offset lithography and bound in Kyoto, Japan, by Nissha Printing Company.

Georgia O'Keeffe: One Hundred Flowers is the first volume in the Collected Works of Georgia O'Keeffe, published by Alfred A. Knopf, in association with Callaway Editions. *In The West* was published in the fall of 1989, and *The New York Years* will be released in the fall of 1991.

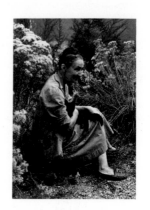